THIS BOOK IS DEDICATED TO

THE PEOPLE OF THE PHILIPPINES, THEIR WEAPONS AND ARTIFACTS,

OUR FAMILIES AND THE TO ALL OUR FRIENDS OF MOROLAND.

GOD BLESS YOU ALL!

INTRODUCTION

This book was created as a Historical Pictorial Publication for use by collectors and people wanting to have a reference guide for DaYak Shields. These shields range in size from miniature shields just two inches in height to over six feet in height.

Each shield has its own story to tell as to who made it, how it was made and what purpose was it made for. These shields have many uses such as protection from arrows during fighting with enemies, for ceremonies and to be sold\traded as tourist souvenirs.

Many of these shields are painted in bright colors to ward off evil spirits and scare the enemy. Some of these shields have different types of carving on them from faces, animals, flowers, basic pictorial scenes. These shields are made out of many types of wood, shells and rattan. Some of these shields are stained and others have no stain at all.

The shields in this book were purchased from many different sellers, from many different countries. Determining the exact age of any of these shields is a difficult task to accomplish without the original owner and craftsman being on site to verify when it was made.

The Moroland Museum field collections team uses reference books, their personal knowledge of the shields and information received from the previous owner to give an approximate age only for each shield. The Moroland Museum Field collections Team has determined the approximate date range of the shields displayed in these books is from 1900's up to the early 1980's.

BACKGROUND

DaYak Headhunter Tribes Historical Background:

This book represents a unique part of the Malaysia history. The shields in this book were purchased from many different sellers, from many different countries. Although the exact age of these shields are hard to determine, The Moroland Musuem field collections specialist have meet many of the original people who purchased these shields while they were in the military (veterans) or as tourist giving the Moroland Museum an approximate date range as to the age of the shields presented in these books. These shields were purchased by their original owners starting from 1940's, up to the early 1990's.

DaYak People:

The DaYak are the native people of Borneo. It's a loose term for over 200 riverine and hill-dwelling ethnic subgroups, located principally in the interior of Borneo, each with its own dialect, customs, laws, territory and culture, although common distinguishing traits are readily identifiable.

The DaYak people of Borneo possess an indigenous account of their history, mostly in oral literature, partly in writing in papan turai (wooden records), and partly in common cultural customary practices. Among prominent accounts of the origin of the DaYak people includes the mythical oral epic of "Tetek Tahtum" by the Ngaju DaYak of Central Kalimantan, it narrates the ancestors of the all DaYak people descended from the heavens before dispensing from the inland to the downstream shores of Borneo. In the past, the DaYak were feared for their ancient tradition of headhunting practices. In reality not all DaYaks were Hunter-gatherers, most DaYaks were actually farmers.

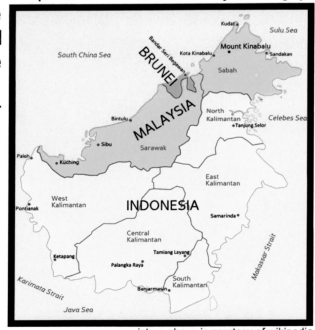

picture above is courtesy of wikipedia

Dayak Shields

of

Moroland Museum

field guide

Eighth Edition
Volume #02

Written by

Author/Publisher	Graphic Artist	Photographer	Legal Council
Bruce Jenkins	**Jess Holloway**	**Bruce Jenkins/**	**Frank Gannon**
Evelyn Jenkins		**Ben VerVer**	

DAYAK SHIELDS OF MOROLAND MUSEUM by Bruce Jenkins

Books may be purchased in quantity and/or special sales by contacting Moroland Museum at:

www.morolandmuseum.com
morolandmuseum@gmail.com

Published by: Moroland Museum
Author & Photography by: Bruce Jenkins & Evelyn Jenkins
Graphic Artist by: Jess Holloway

First Edition

Printed in USA

BACKGROUND

Volumes:

This book is the second volume in a multi-volume set of books documenting these unique DaYak shields from the Malaysia/Borneo. As the Moroland Museums' collection of DaYak shields continues to grow, the Moroland Museum Historical Publications team will continue their dedication to get these books published for all people to enjoy.

Hard to find:

The older DaYak shields are getting hard to find and even harder to find in good condition. The shields crafted prior to the 1940's are the most difficult to find, due to a lot of them being destroyed during the Japanese occupation of the Malaysia/Borneo during WWII and to the environment they were stored in.

Military Personnel's influence on these DaYak Shields:

Although many tourist have brought these shields home from the Malaysia/Borneo area, the majority of these shields were brought home by the Service men\women from the major wars (WWII, Korea, Vietnam) and while on deployment to (near) the area during peaceful times. They were brought home as souvenirs from their foreign country travels to share with their families and friends.

Craftsmanship and Quality:

Most of these shields show a very high level of craftsmanship and quality. When you inspect the different types of DaYak shields, the detail put into each one is obvious as they are like masterpieces on which the craftsman shows off their talents.

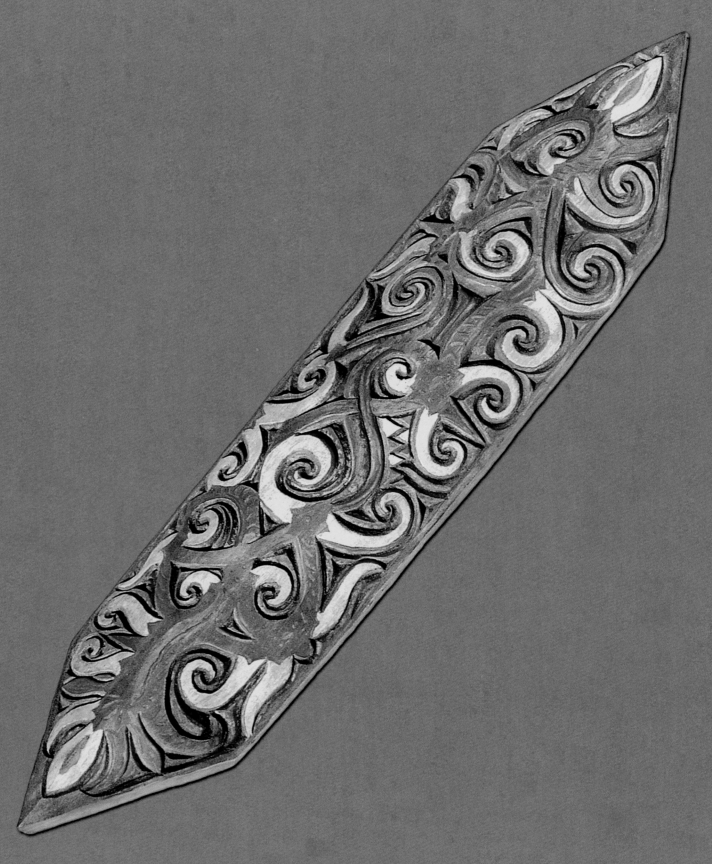

DaYak Shield #01

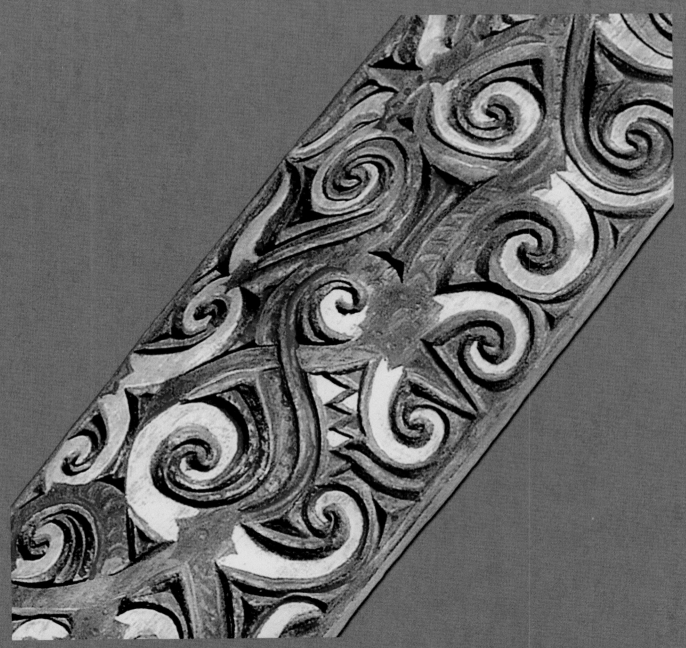

DaYak Shield #01

Description: Old DaYak Head Hunters arrow\weapons deflection shield. This colorful hand carved and painted shield is from Borneo. It has deeply carved traditional ASO Ibanic carvings and colors on it.

Location Found:	Sarawak, Malaysia	**Length:**	27 inches
Location Purchased:	EBay	**Width:**	6 inches
Approximate Age:	1960's	**Condition:**	Museum Quality

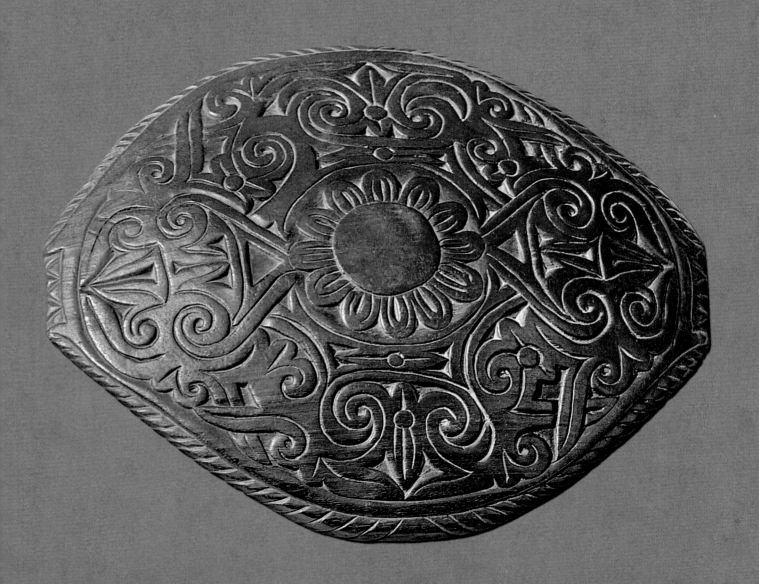

DaYak Shield #02

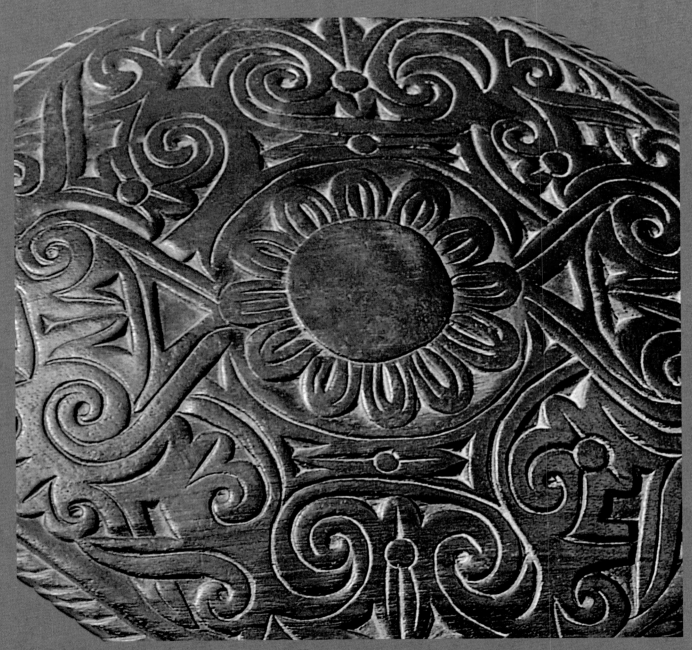

DaYak Shield #02

Description: An old authentic circular Ibanic DaYak Kumang warrior shield used for the Harvest festival. It is hand carved from belian (ironwood). It has Tree Of Life and traditional ASO Naga designs carved in it.

Location Found:	Sarawak, Malaysia	**Height:**	16 inches
Location Purchased:	Ebay	**Width:**	14 inches
Approximate Age:	1960's	**Condition:**	Museum Quality

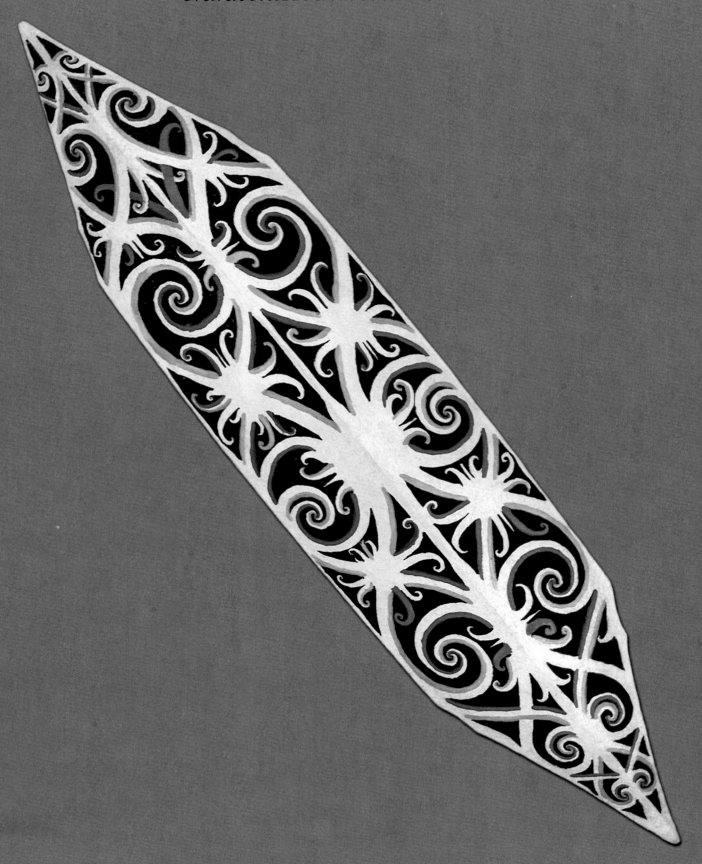

DaYak Shield #03

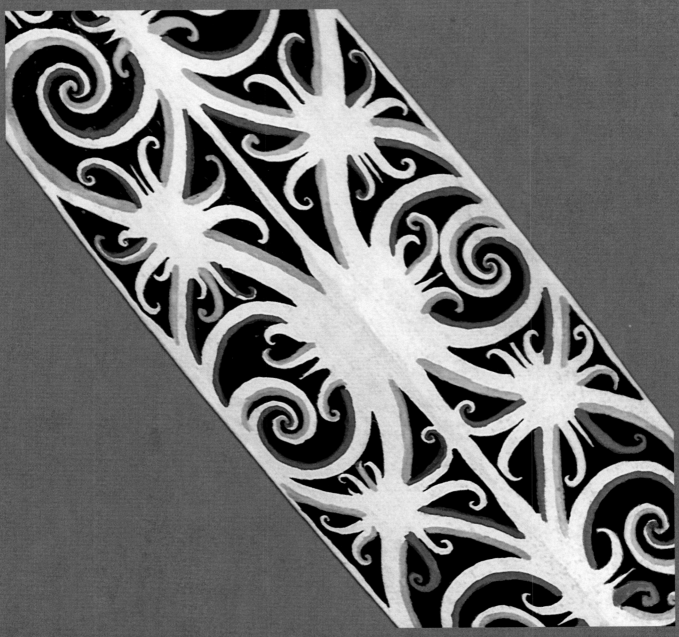

DaYak Shield #03

Description: Vintage hand painted DaYak Head Hunter warrior shield. This shield is from the Kalimantan\Borneo area. Hand carved from a single piece of wood. All hand painted with Mata Aso/Dragon Eye, Tree of Life & Orang Ulu anthropomorphic figures.

Location Found:	Borneo, Indonesia	**Length:**	37 inches
Location Purchased:	EBay	**Width:**	8 inches
Approximate Age:	1950's	**Condition:**	Museum Quality

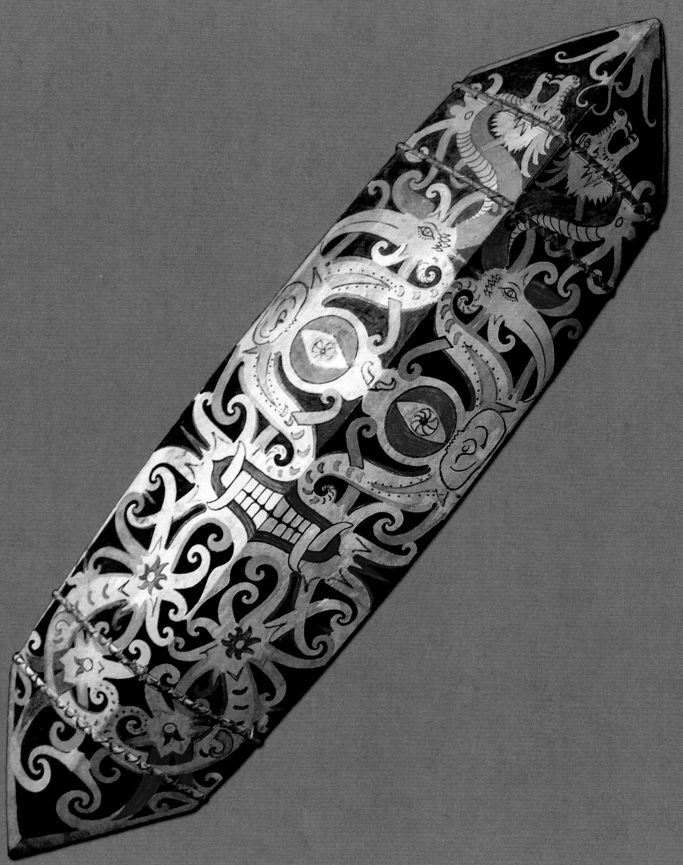

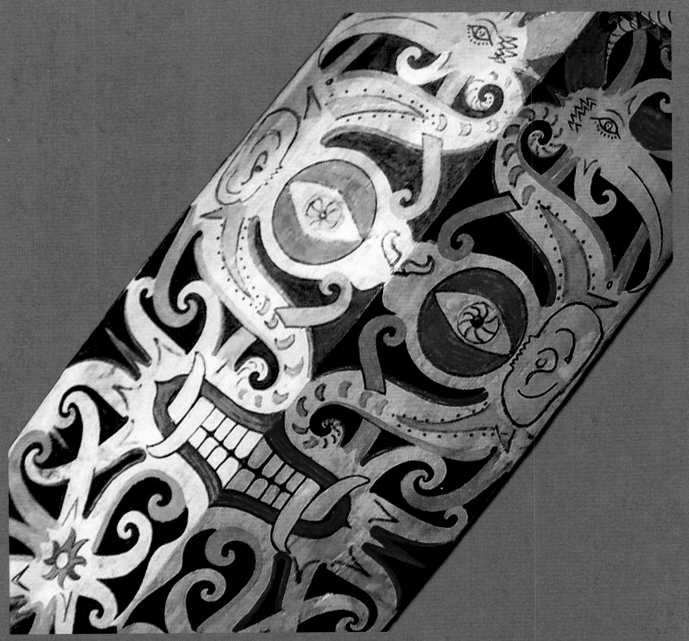

DaYak Shield #04

Description: This is a DaYak shield made in Sarawak, Malaysia. It is very old and has the traditional colorings of the DaYak headhunters. It has two sets of rattan wrappings on the top and bottom. This type of shield was commonly used by DaYak headhunters during their ceremonies.

Location Found:	Sarawak, Malaysia	**Length:**	45 inches	
Location Purchased:	EBay	**Width:**	11 inches	
Approximate Age:	1900's	**Condition:**	Museum Quality	

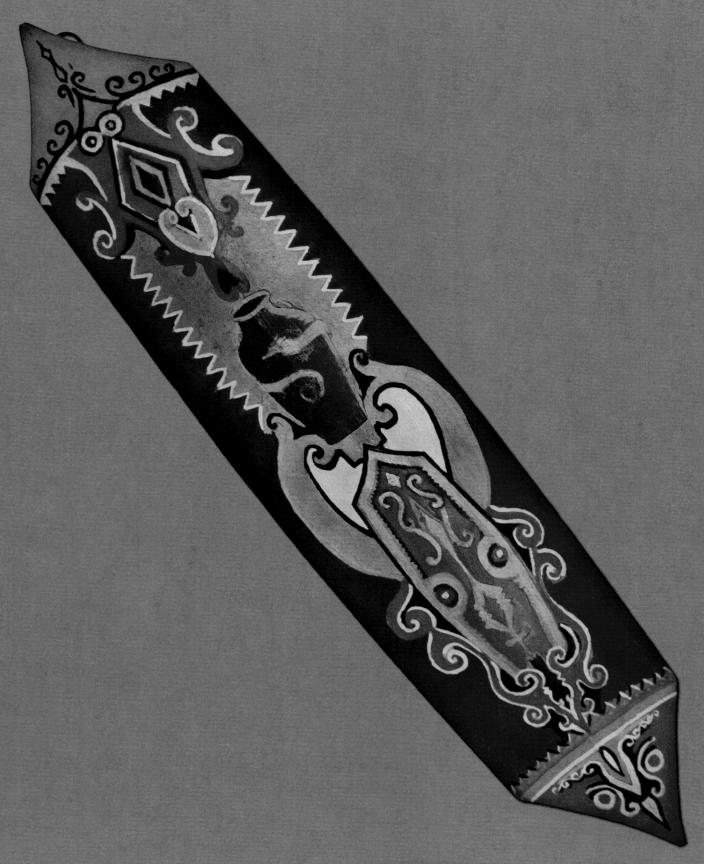

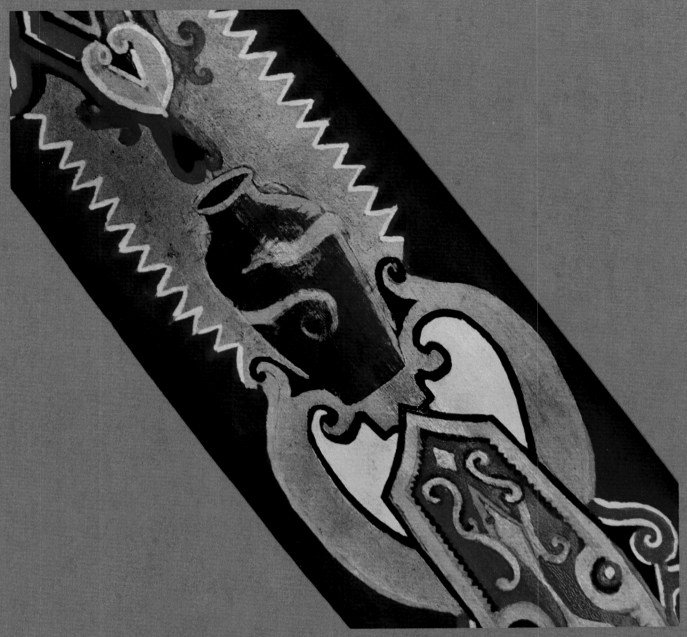

DaYak Shield #05

Description: This is an old DaYak shield that has the traditional colorings of the DaYak head hunters. It has mystical items hand painted on the shield. These items include a storage vase with a snake wrapped around it and another IBAN ASO shield. This type of shield was commonly used by DaYak headhunters during their Kumang Gawai\Harvesting Festival Ceremonies.

Location Found:	Sarawak, Malaysia	**Length:**	35 inches
Location Purchased:	EBay	**Width:**	7 inches
Approximate Age:	1970's	**Condition:**	Museum Quality

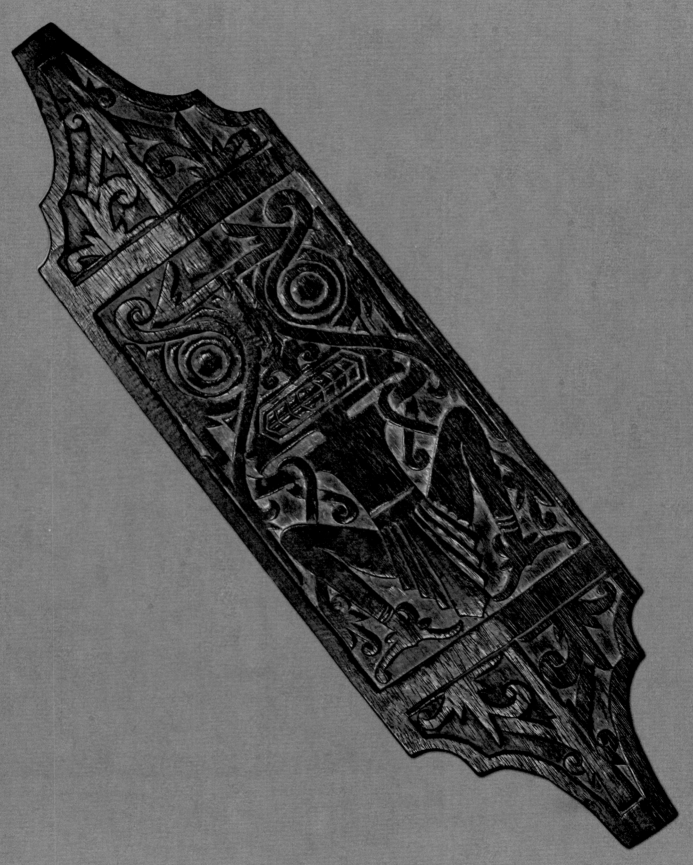

DaYak Shield #06

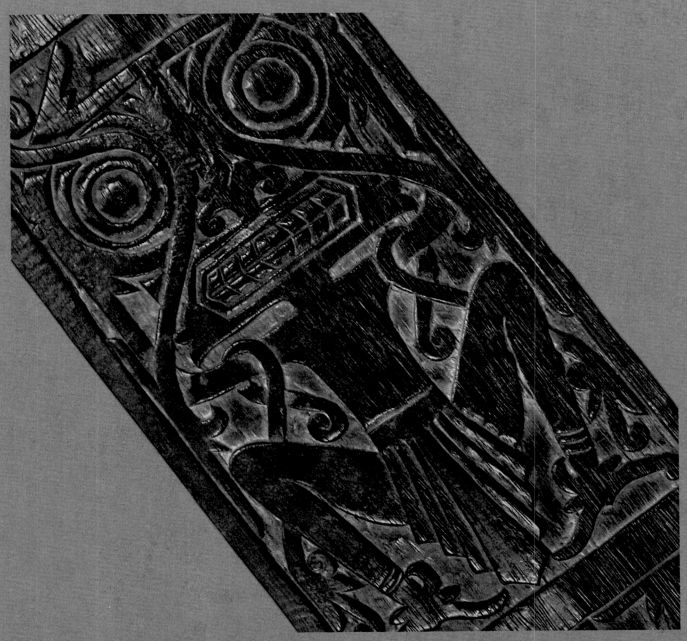

DaYak Shield #06

Description: An old authentic Ibanic DaYak Kumang shield used for the Harvest festival. It is made from belian (ironwood) and has a carved Demon warrior on it. It is a hand carved shield from a single piece of wood.

Location Found:	Sarawak, Malaysia	**Length:**	28 inches
Location Purchased:	Ebay	**Width:**	8 inches
Approximate Age:	1960's	**Condition:**	Museum Quality

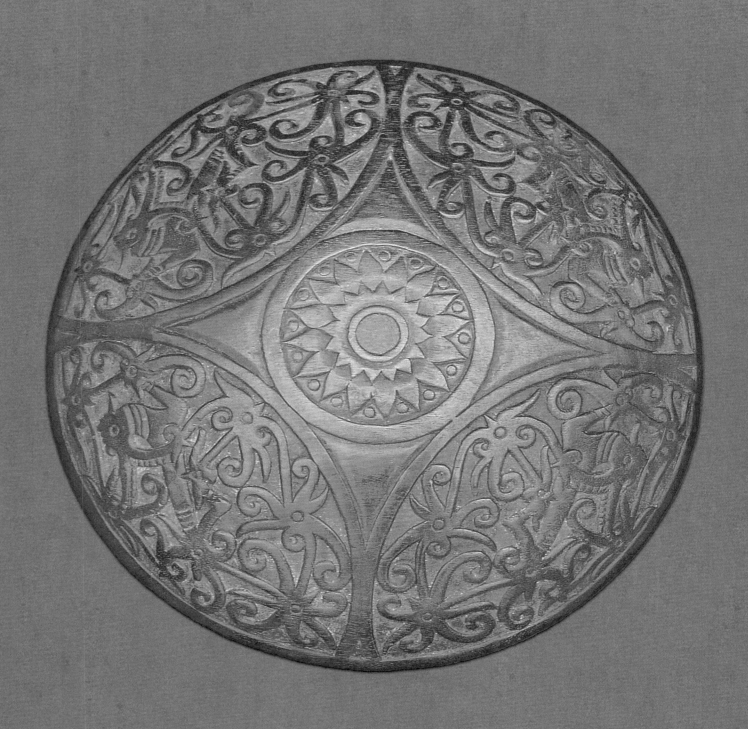

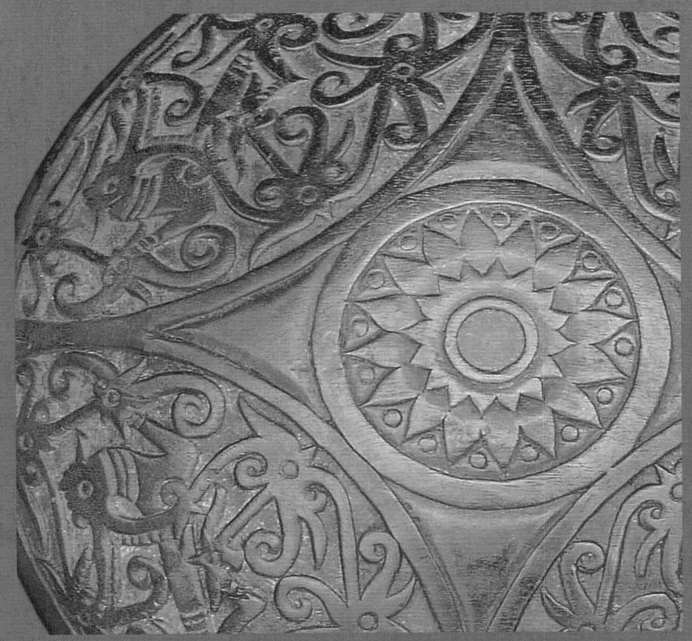

DaYak Shield #07

Description: An authentic circular Ibanic Sea DaYak Kumang warrior ceremonial shield. It is hand carved from a single piece of belian (ironwood). It has Tree Of Life and traditional ASO Naga designs carved in it.

Location Found:	Sarawak, Malaysia	**Circular Width:**	20 inches
Location Purchased:	Ebay	**Thickness:**	1.5 inches
Approximate Age:	1960's	**Condition:**	Museum Quality

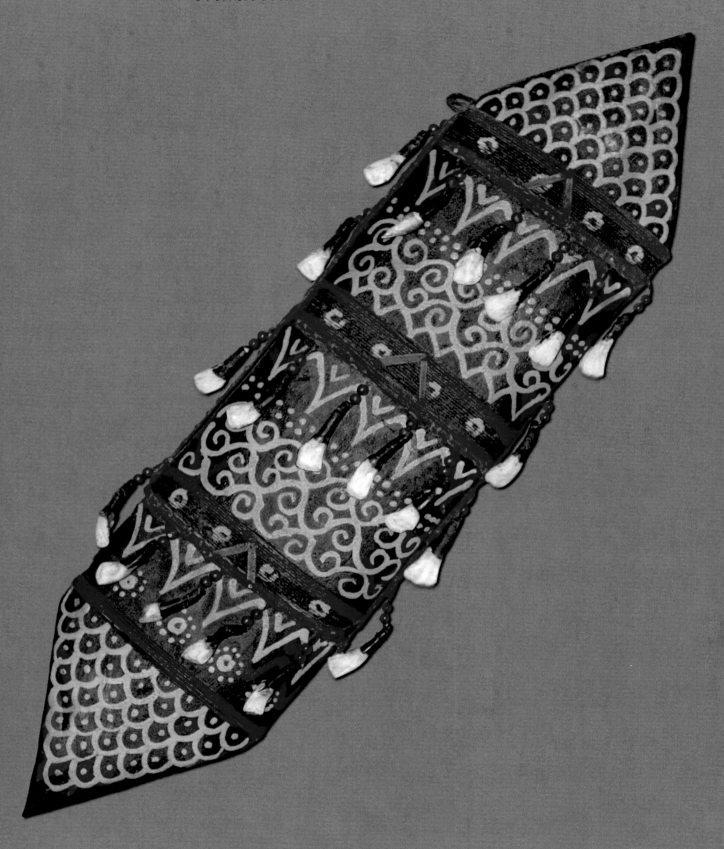

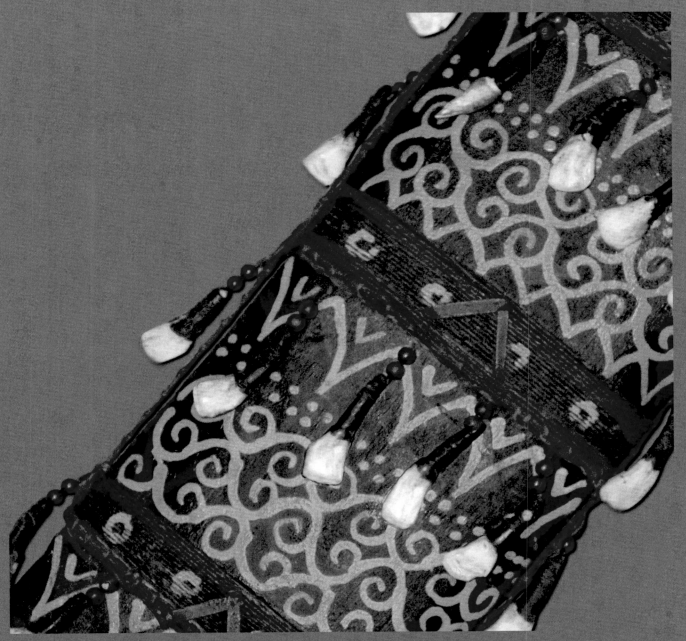

DaYak Shield #08

Description: Old small DaYak Head Hunters shield. This colorful hand carved shield is from Borneo and is carved from a single piece of wood. Hand painted with Mata ASO IBAN designs. It is adorned with symbolic pig's teeth and beads.

Location Found:	Sarawak, Malaysia	**Length:**	20 inches
Location Purchased:	Gun Show	**Width:**	5 inches
Approximate Age:	1980's	**Condition:**	Above Average

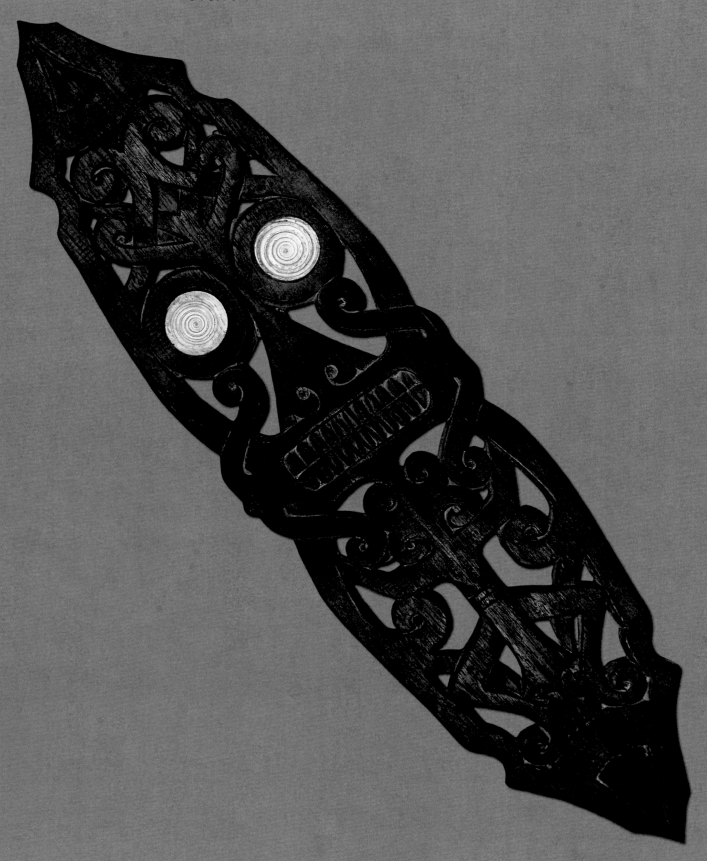

DaYak Shield #09

Description: An old authentic Ibanic DaYak Kumang shield for the wedded male family Hardwood. Decorated with Anthropomorphic Face (both eyes studded with old seashell) and everything here is hand-carved. Amazing authentic old shield from Sarawak.

Location Found:	Sarawak, Malaysia	**Length:**	30 inches
Location Purchased:	Ebay	**Width:**	8 inches
Approximate Age:	1950's	**Condition:**	Museum Quality

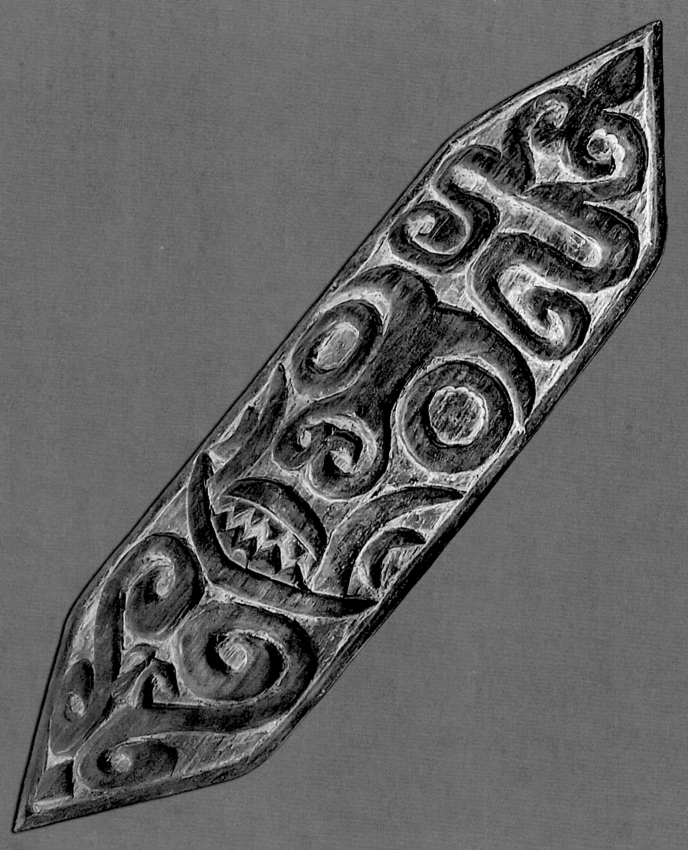

DaYak Shield #10

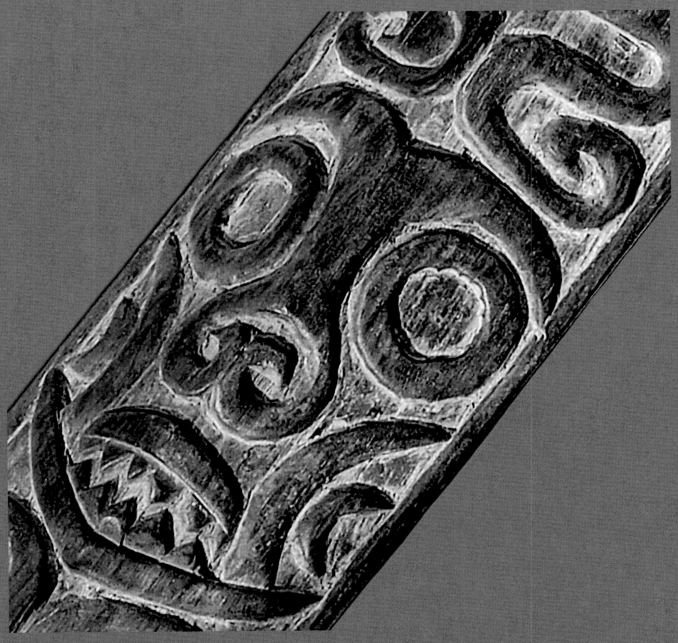

DaYak Shield #10

Description: An old authentic Ibanic DaYak Headhunter shield. It is hand carved from belian (ironwood). It has a Demon face and traditional ASO Naga designs carved in it.

Location Found:	Sarawak, Malaysia	**Length:**	25 inches
Location Purchased:	Ebay	**Width:**	12 inches
Approximate Age:	1950's	**Condition:**	Museum Quality

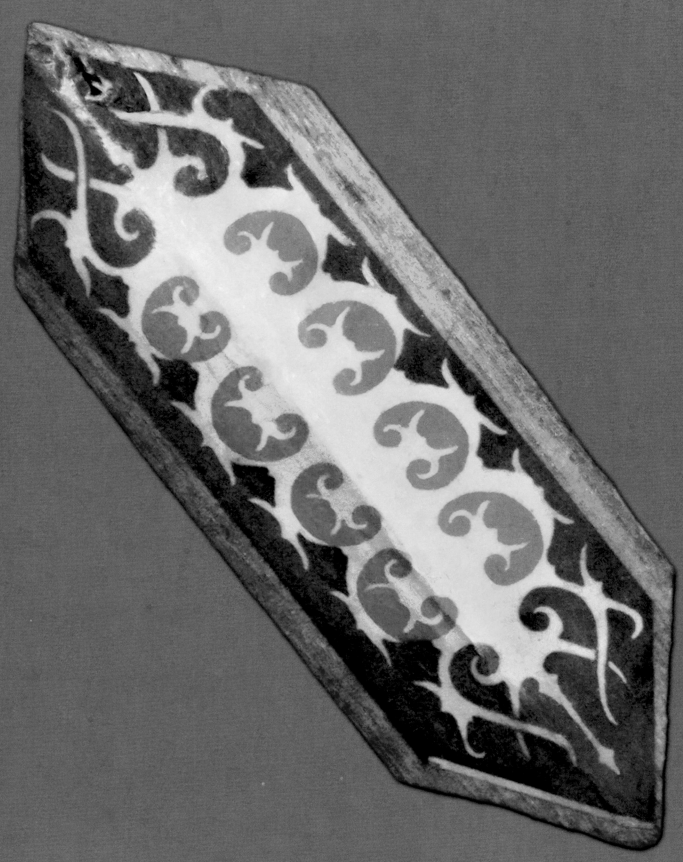

DaYak Shield #11

DaYak Shield #11

Description: This is a colorful miniature replica of a DaYak Head Hunters arrow\weapons deflection shield. This shield is carved from a single piece of wood. All hand painted with Mata ASO/Dragon Eye, Tree of Life & Orang Ulu anthropomorphic figures.

Location Found:	Sarawak, Malaysia	**Height:**	2 inches
Location Purchased:	Ebay	**Width:**	1 inches
Approximate Age:	2004's	**Condition:**	Museum Quality

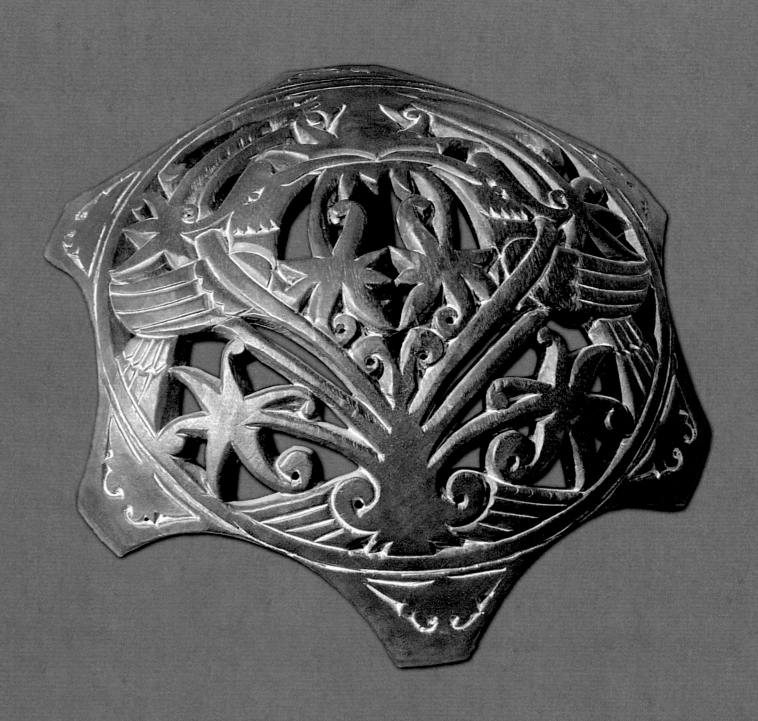

DaYak Shield #12

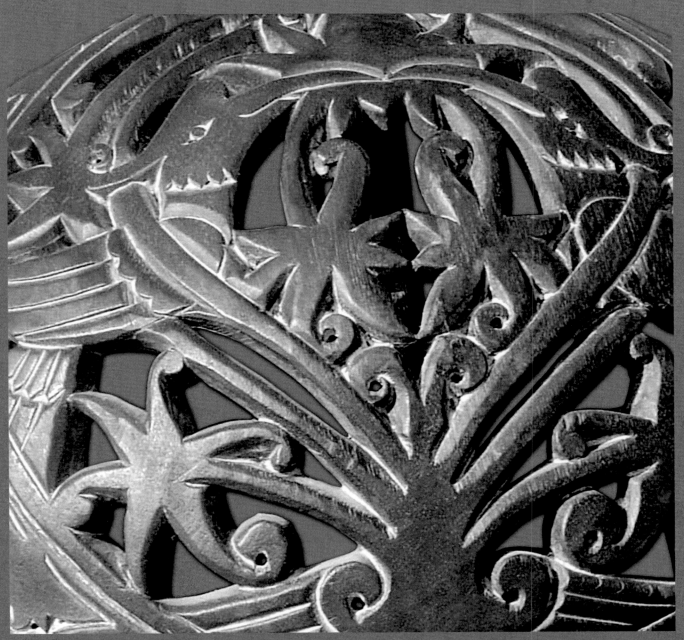

DaYak Shield #12

Description: An old authentic star shaped Ibanic DaYak Kumang warrior shield used for the Harvest festival. It is hand carved from belian (ironwood). It has Tree Of Life, Two horn billed birds and traditional ASO Naga designs carved in it.

Location Found:	Sarawak, Malaysia	**Height:**	12 inches
Location Purchased:	Ebay	**Width:**	1.5 inches
Approximate Age:	1970's	**Condition:**	Museum Quality

DaYak Shield #13

DAYAK SHIELDS of MOROLAND MUSEUM

DaYak Shield #13

Description: DaYak handcarved warrior shield, made out of one piece of wood. The shield has beautiful symbolic carvings on it. This shield was brought to the USA after the Korean War by a military veteran.

Location Found:	Sarawak, Malaysia	**Height:**	29 inches
Location Purchased:	Ebay	**Width:**	7.5 inches
Approximate Age:	1950's	**Condition:**	Above Average

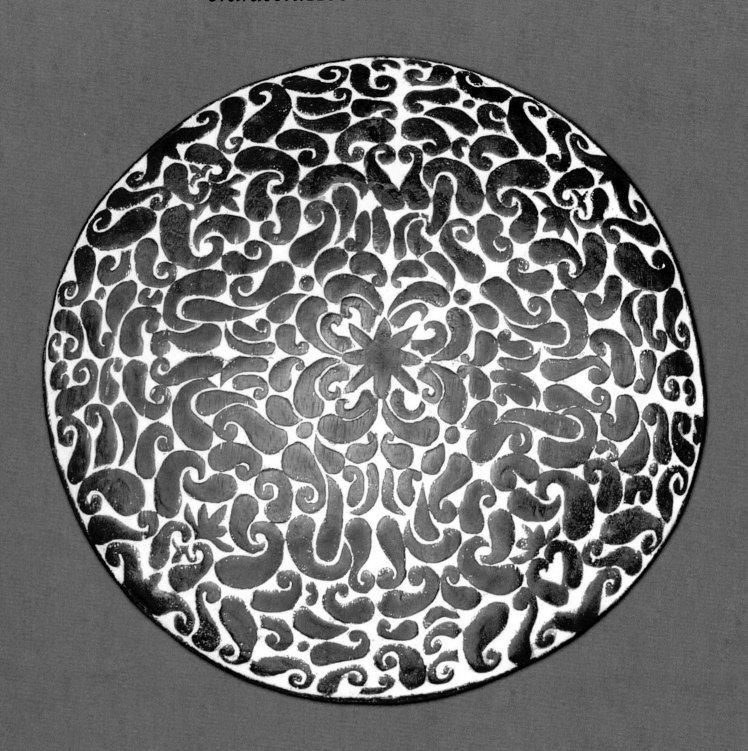

DaYak Shield #14

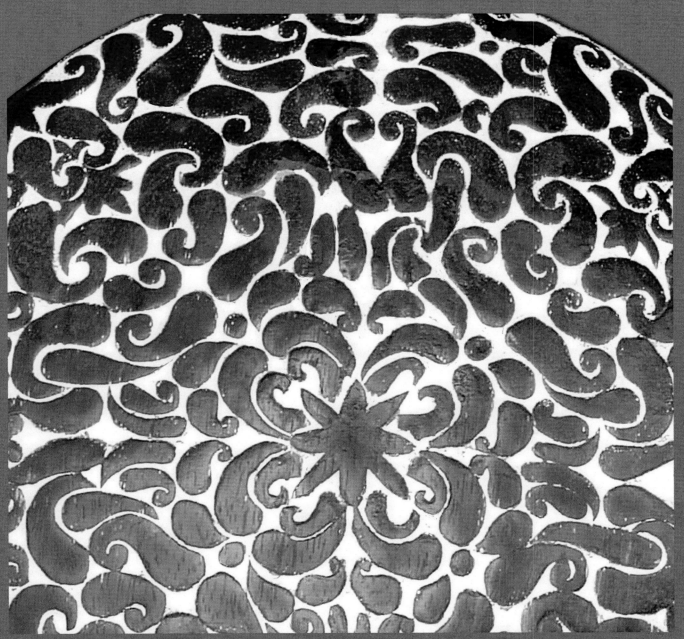

DaYak Shield #14

Description: An authentic circular Ibanic Sea DaYak Kumang warrior ceremonial shield. It is handcarved from belian (ironwood). It has traditional ASO Naga designs carved in it.

Location Found:	Sarawak, Malaysia	**Circular Width:**	20 inches
Location Purchased:	Ebay	**Thickness:**	1.5 inches
Approximate Age:	1970's	**Condition:**	Museum Quality

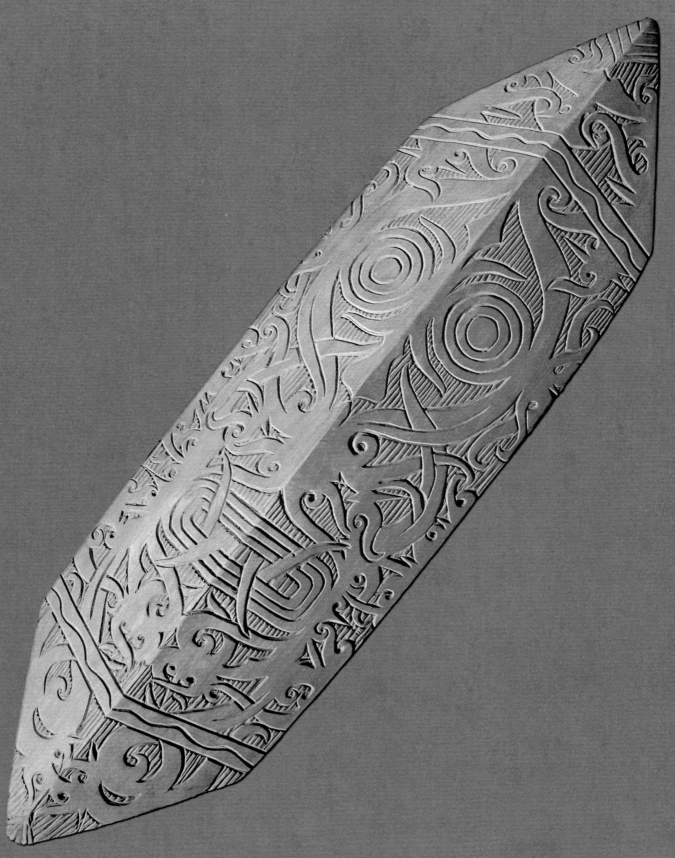

DaYak Shield #15

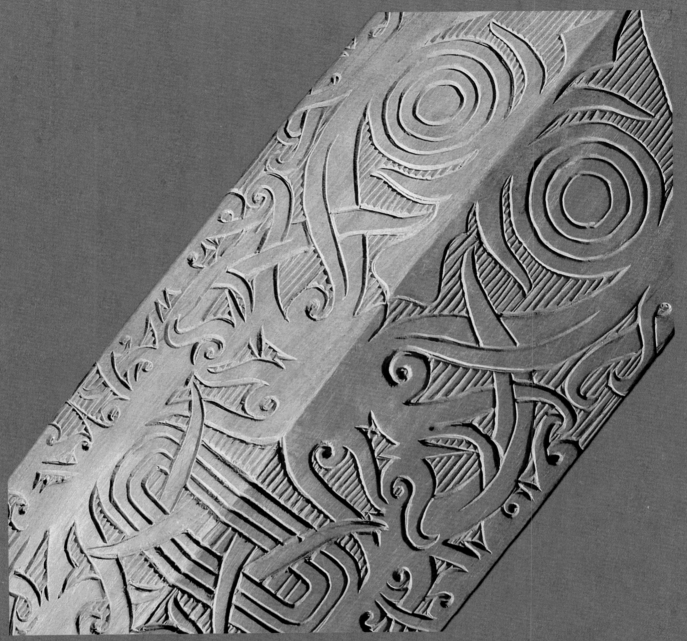

DaYak Shield #15

Description: This is an authentic old Ibanic DaYak shield that is decorated with traditional ASO Naga and Tree Of Life carvings of the DaYak headhunters. It is carved from a single piece of belian (Ironwood) wood.

Location Found:	Sarawak, Malaysia	**Height:**	41 inches
Location Purchased:	Ebay	**Width:**	13 inches
Approximate Age:	1960's	**Condition:**	Museum Quality

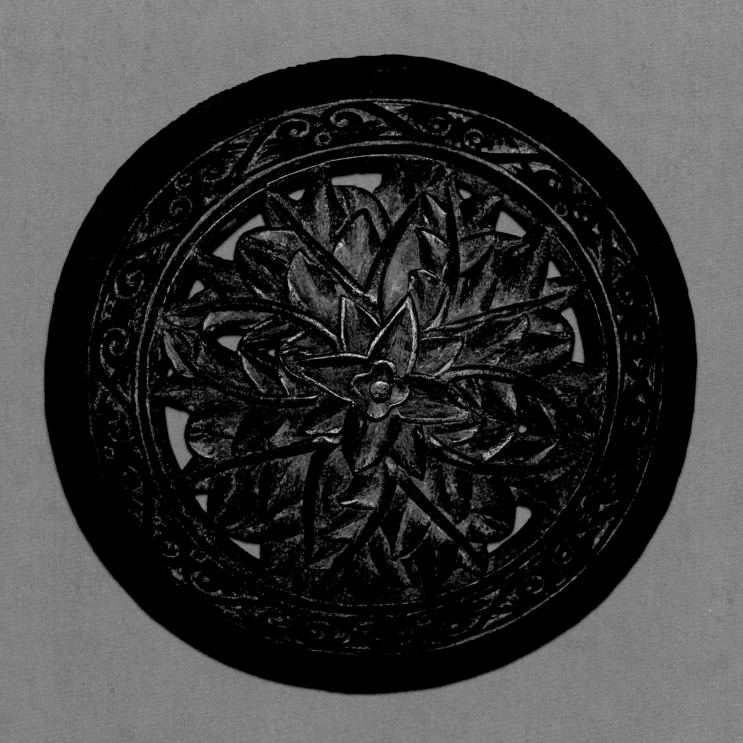

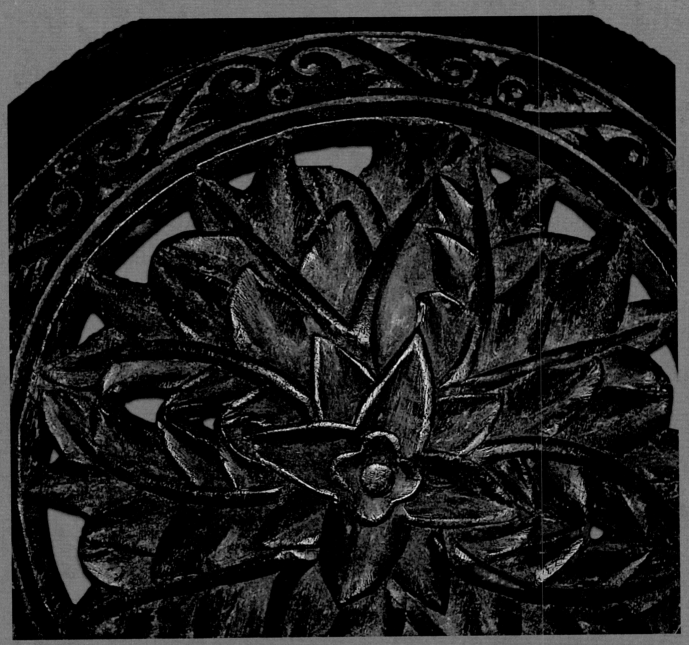

DaYak Shield #16

Description: An authentic circular Ibanic Sea DaYak Kumang warrior ceremonial shield. It is handcarved from a single piece of belian (ironwood). It has a flower pattern and traditional ASO Naga designs carved in it.

Location Found:	Sarawak, Malaysia	**Circular Width:**	20 inches
Location Purchased:	Ebay	**Thickness:**	1.5 inches
Approximate Age:	1950's	**Condition:**	Museum Quality

DaYak Shield #17

Description: This is a colorful miniature replica of a DaYak Head Hunters arrow\weapons deflection shield. This shield is carved from a single piece of wood. All hand painted with Mata Aso/Dragon Eye, Tree of Life & Orang Ulu anthropomorphic figures.

Location Found:	Sydney, Australia	**Height:**	16 inches
Location Purchased:	Ebay	**Width:**	4 inches
Approximate Age:	1980's	**Condition:**	Museum Quality

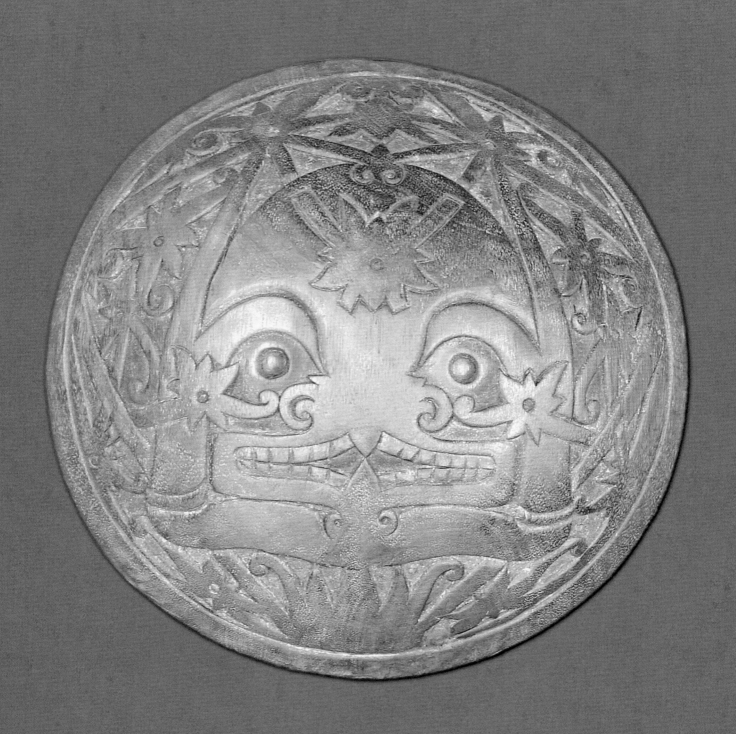

DaYak Shield #18

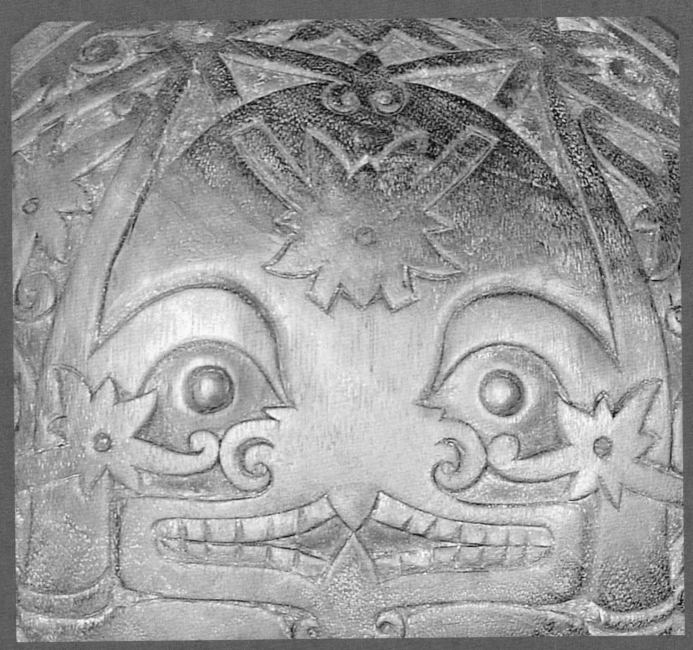

DaYak Shield #18

Description: An old authentic circular Ibanic DaYak Kumang warrior shield used for the Harvest festival. It is handcarved from belian (ironwood). It has Tree Of Life, Demon face and traditional ASO Naga designs carved in it.

Location Found:	Sarawak, Malaysia	**Circular Width:**	12 inches
Location Purchased:	Ebay	**Thickness:**	1.5 inches
Approximate Age:	1970's	**Condition:**	Museum Quality

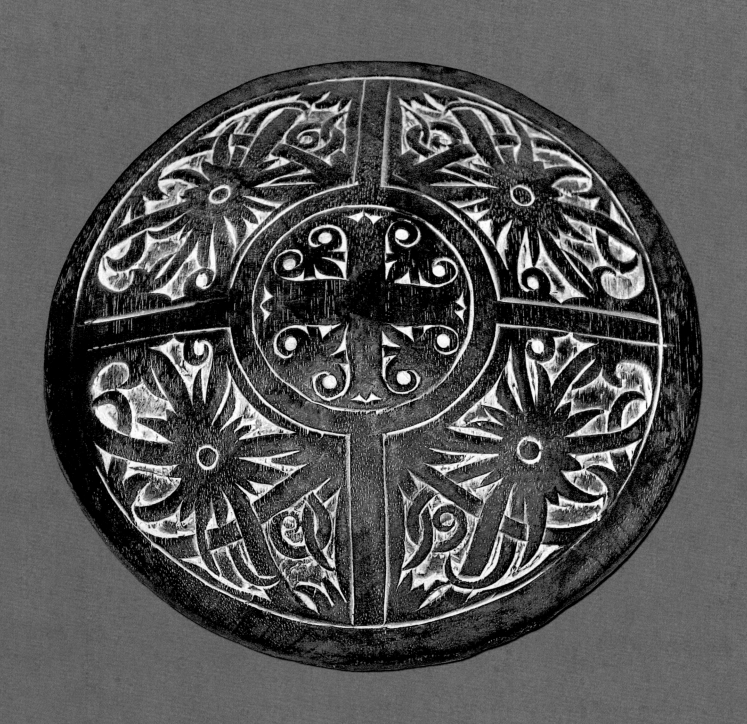

DaYak Shield #19

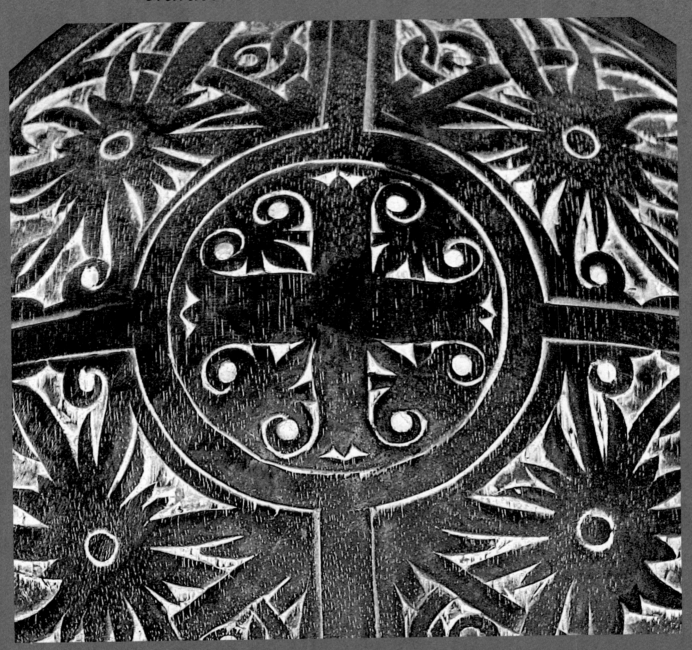

DaYak Shield #19

Description: An old authentic circular Ibanic DaYak Kumang warrior shield used for the Harvest festival. It is hand carved from belian (ironwood). It has Tree Of Life and traditional ASO Naga designs carved in it.

Location Found:	Sarawak, Malaysia	**Circular Width:**	12 inches
Location Purchased:	Ebay	**Thickness:**	1.5 inches
Approximate Age:	1970's	**Condition:**	Museum Quality

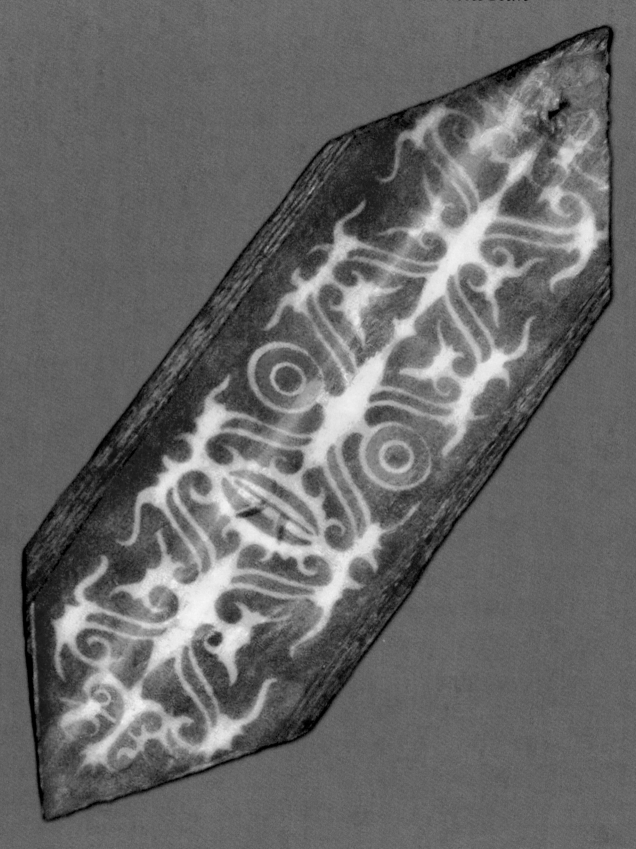

DaYak Shield #20

DaYak Shield #20

Description: This is a colorful miniature replica of a DaYak Head Hunters arrow\weapons deflection shield. This shield is carved from a single piece of wood. All hand painted with Mata ASO/Dragon Eye, Tree of Life & Orang Ulu anthropomorphic figures.

Location Found:	Sarawak, Malaysia	**Height:**	2 inches
Location Purchased:	Ebay	**Width:**	1 inches
Approximate Age:	2004's	**Condition:**	Museum Quality

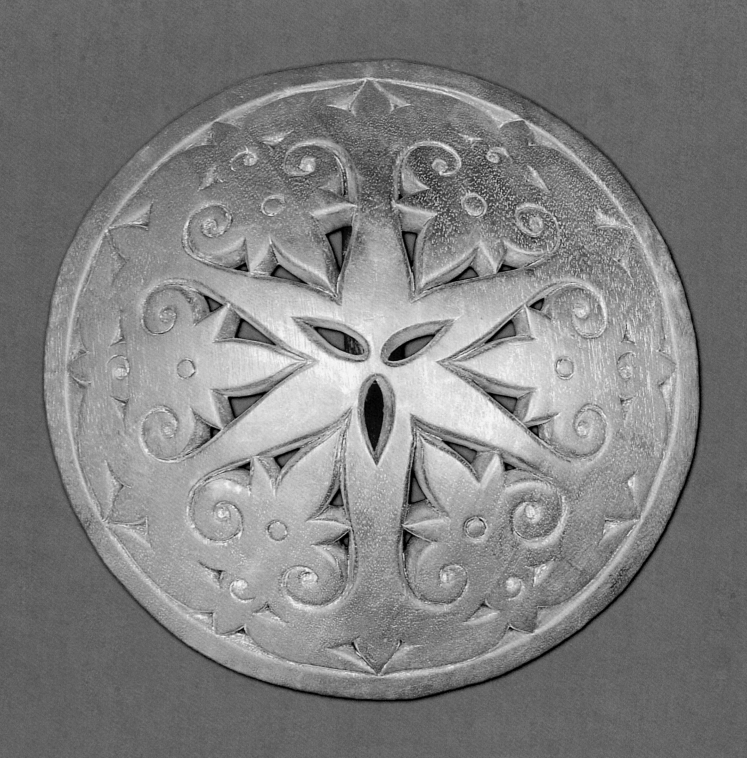

DaYak Shield #21

Description: An old authentic circular Ibanic DaYak Kumang warrior shield used for the Harvest festival. It is handcarved from belian (ironwood). It has Tree Of Life and traditional ASO Naga designs carved in it.

Location Found:	Sarawak, Malaysia	**Circular Width:**	12 inches
Location Purchased:	Ebay	**Thickness:**	1.5 inches
Approximate Age:	1970's	**Condition:**	Museum Quality

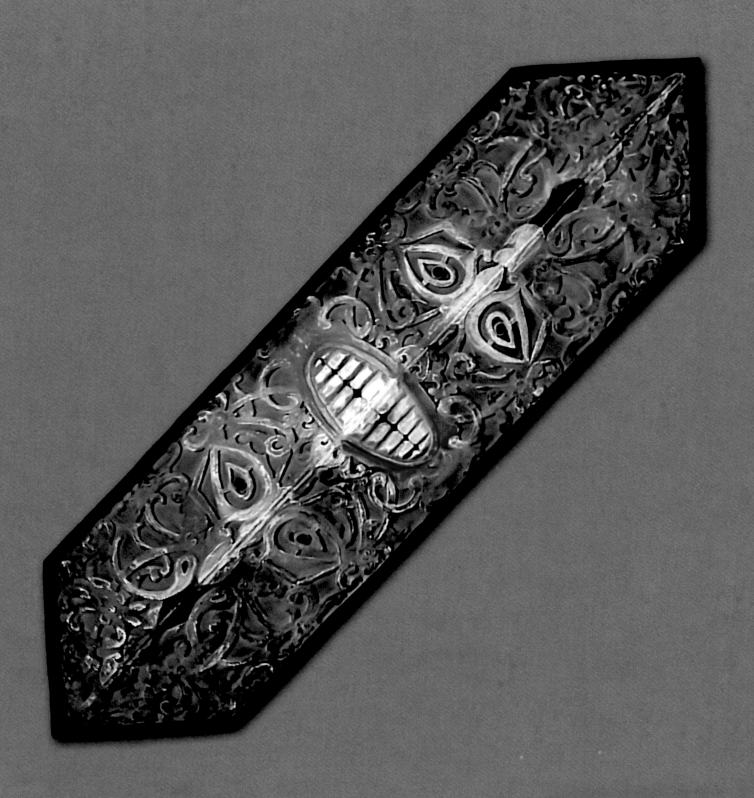

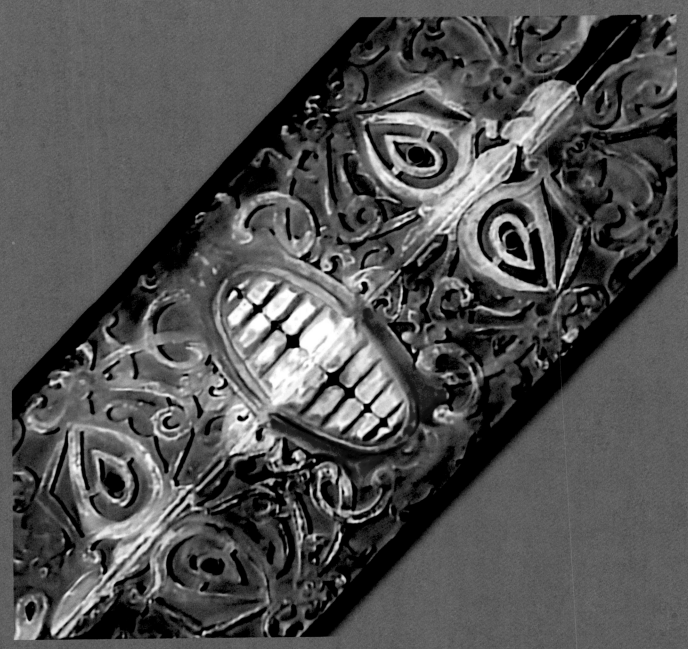

DaYak Shield #22

Description: This is an authentic DaYak Ceremonial Warriors headhunter shield. It is made of very hard wood and is heavy in weight. It features the traditional ASO Naga tree of life carvings with a demons face in the middle. It shows very nice patina on it.

Location Found:	Sarawak, Malaysia	**Height:**	60 inches
Location Purchased:	Ebay	**Width:**	20 inches
Approximate Age:	1900s	**Condition:**	Above Average

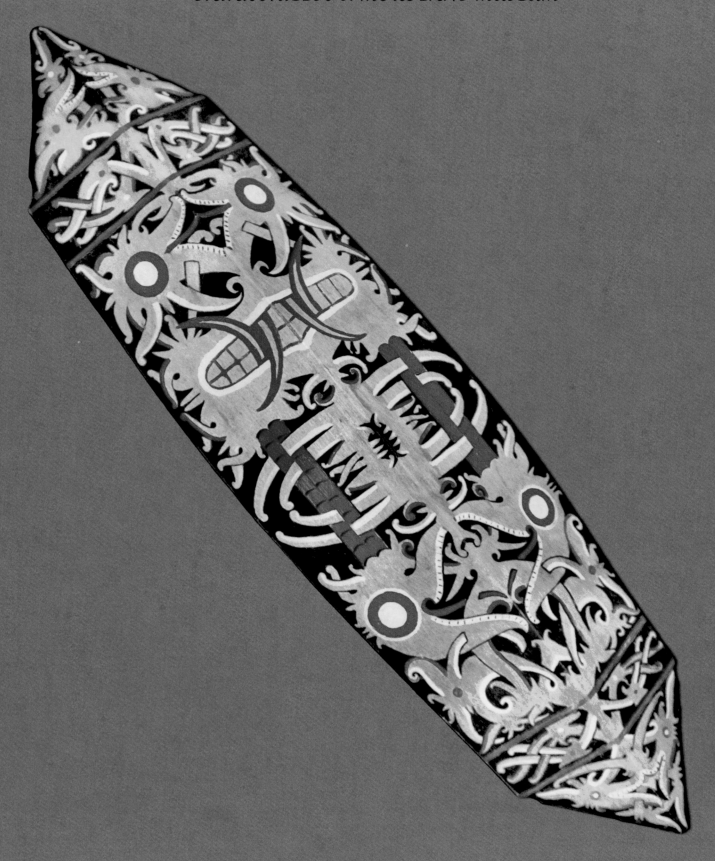

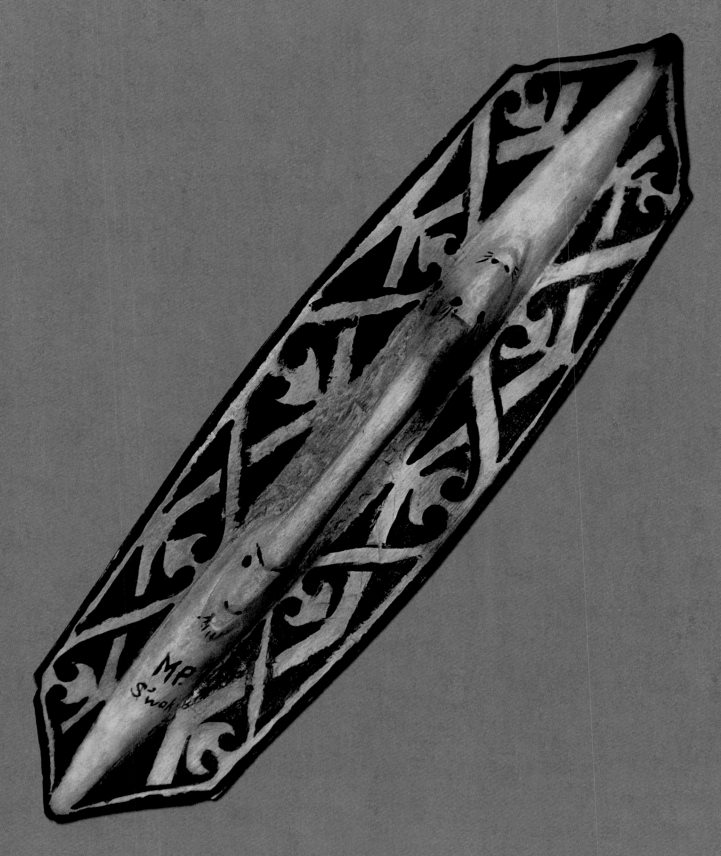

DaYak Shield Back #23

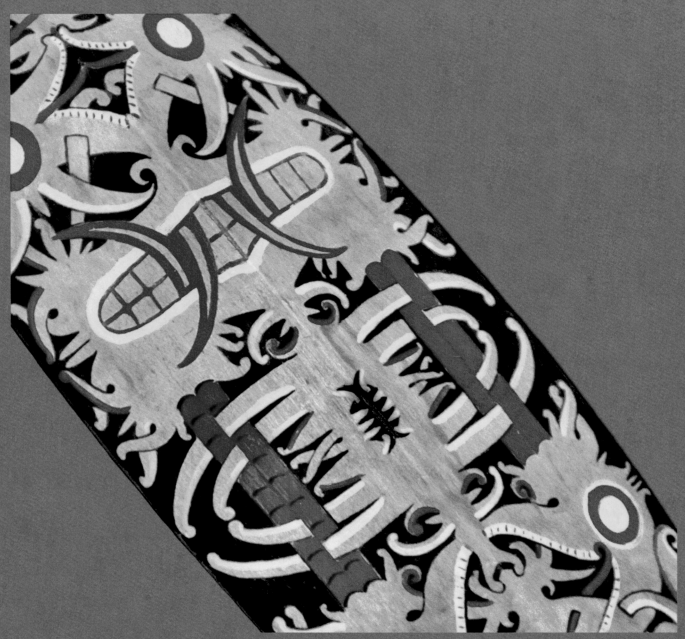

DaYak Shield #23

Description: Old DaYak Head Hunters arrow\weapons deflection shield. This colorful hand carved shield is from Borneo and is carved from a single piece of wood. Hand painted with Mata ASO/Dragon Eye, Tree of Life & Orang Ulu anthropomorphic figures.

Location Found:	Sarawak, Malaysia	**Length:**	35 inches
Location Purchased:	EBay	**Width:**	8 inches
Approximate Age:	1960's	**Condition:**	Museum Quality

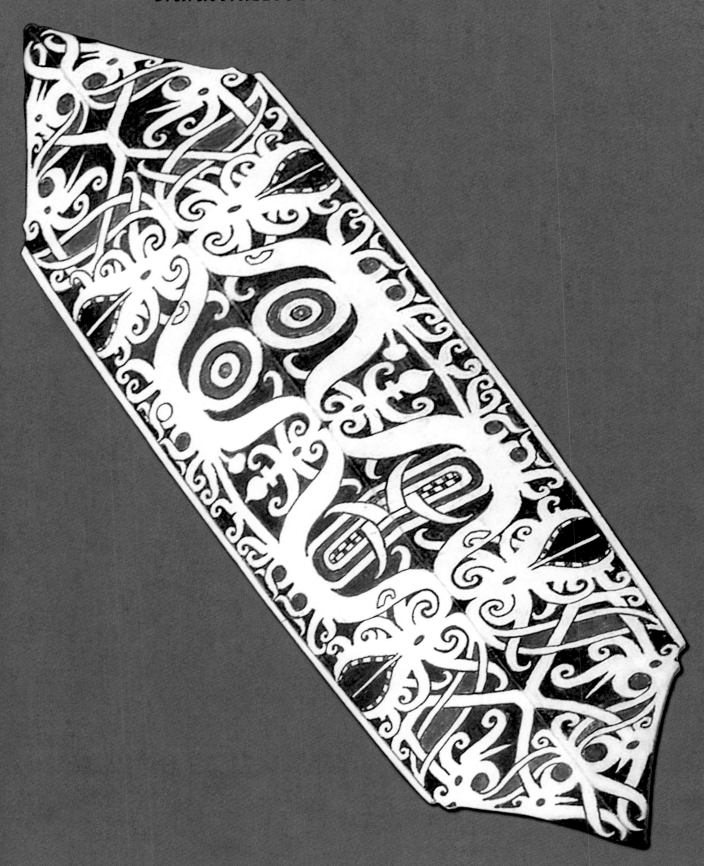

DaYak Shield #24

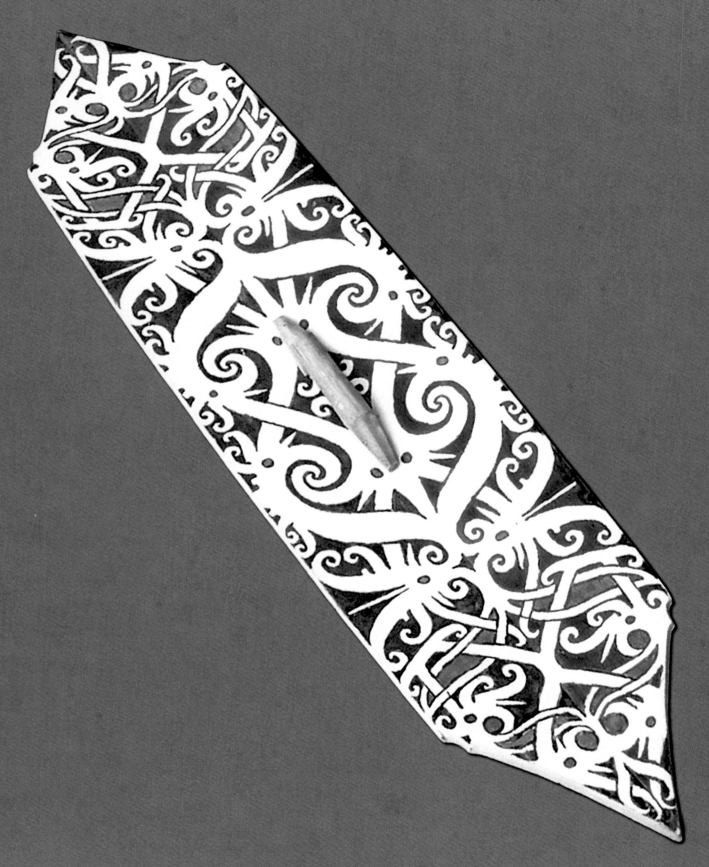

DaYak Shield Back #24

DaYak Shield #24

Description: Old DaYak Head Hunters arrow\weapons deflection shield. This colorful hand carved shield is from Borneo and is carved from a single piece of wood. Hand painted with Mata ASO/Dragon Eye, Tree of Life & Orang Ulu anthropomorphic figures.

Location Found:	Sarawak, Malaysia		**Length:**	37 inches
Location Purchased:	EBay		**Width:**	9 inches
Approximate Age:	1970's		**Condition:**	Museum Quality

LITTLE

EXTRAS

of

MOROLAND

DAYAK SHIELDS
LITTLE
EXTRAS

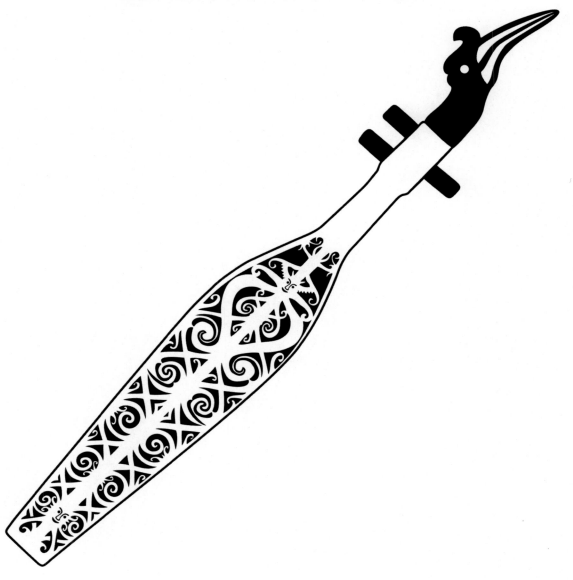

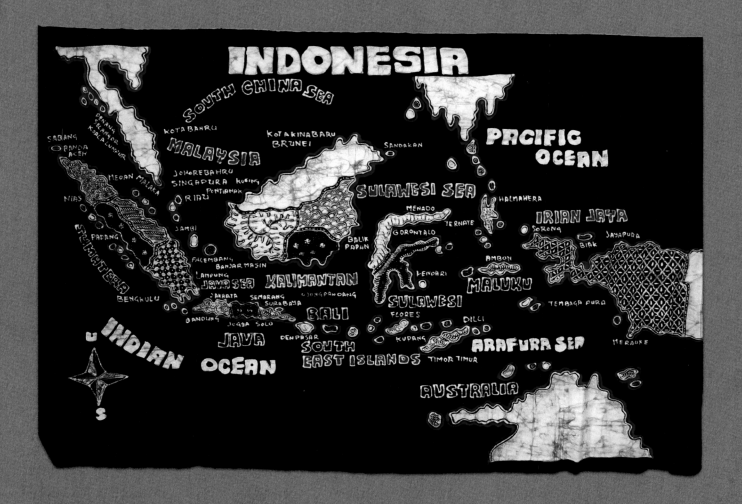

DaYak Extra #01 Cloth Map Of Indonesia

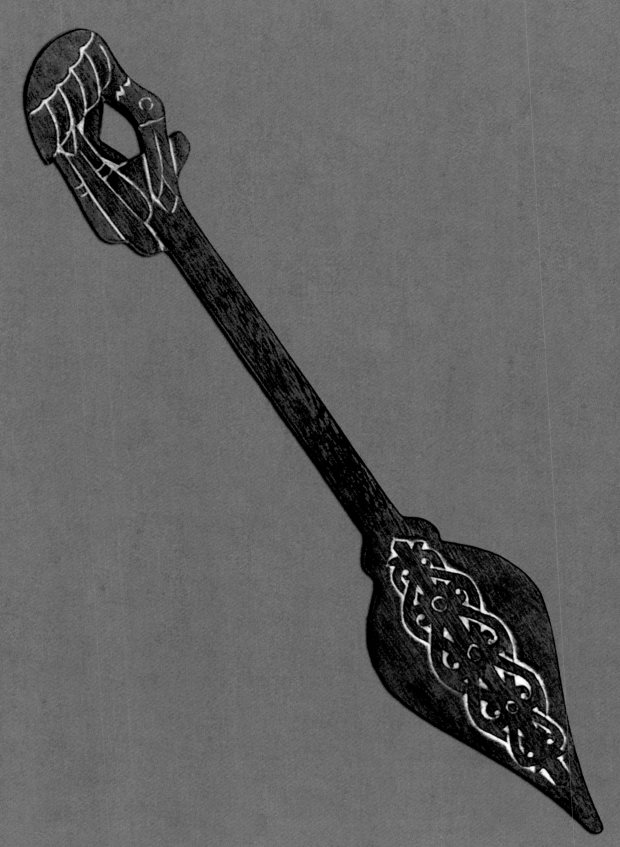

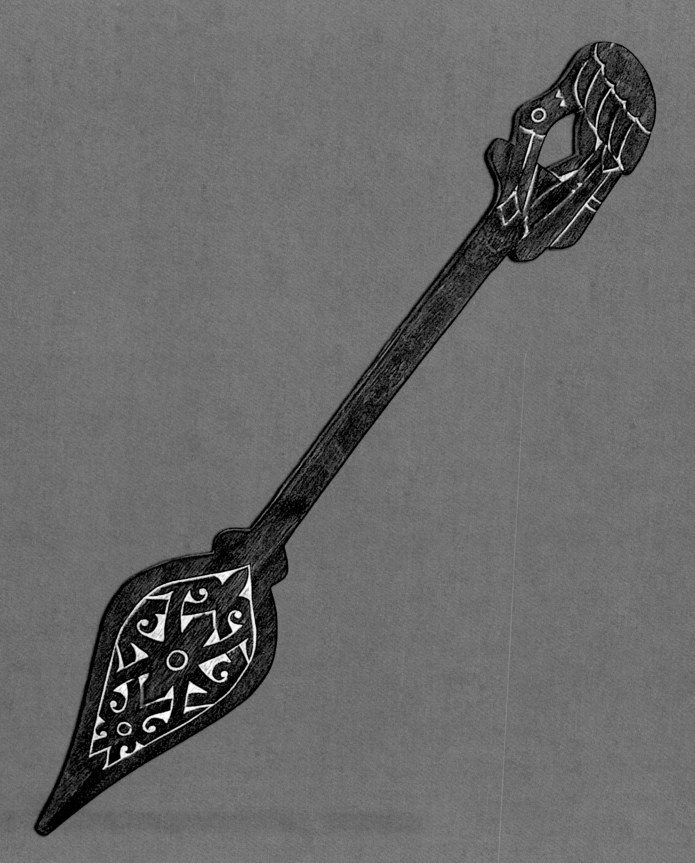

DaYak Extra #03 Headhunter Dugout Canoe Paddle

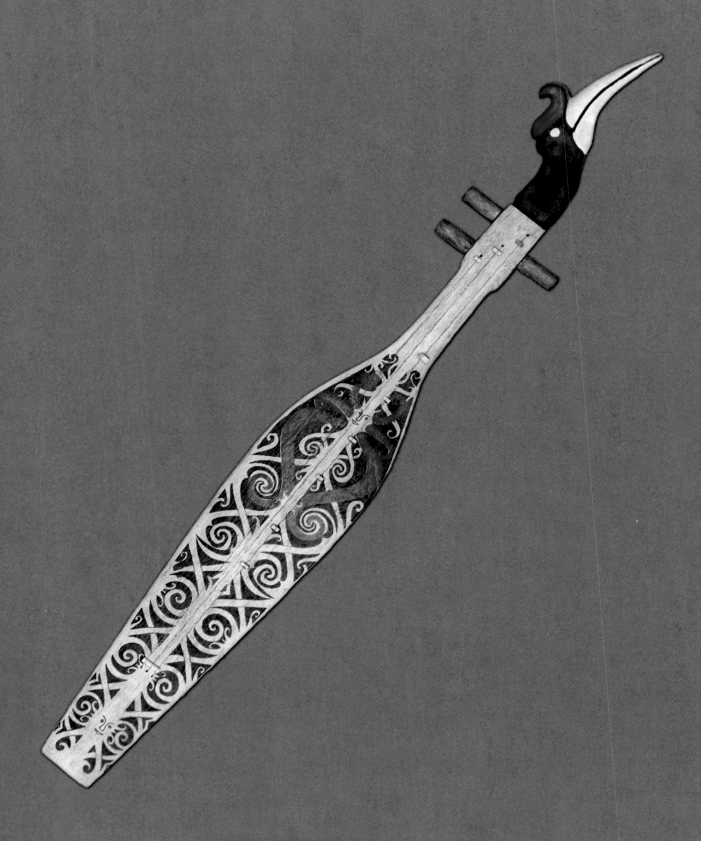

DaYak Extra #04 Hornbill Bird Guitar (Lute)

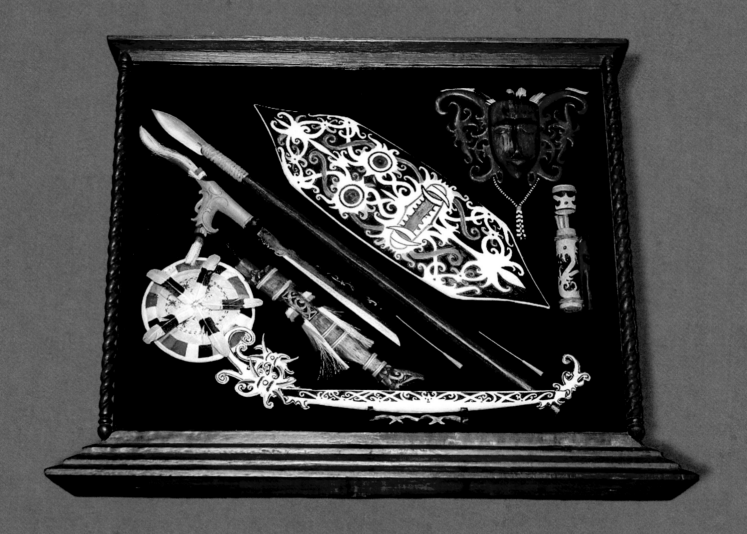

DaYak Extra #05 Headhunter Kalimantan Diorama

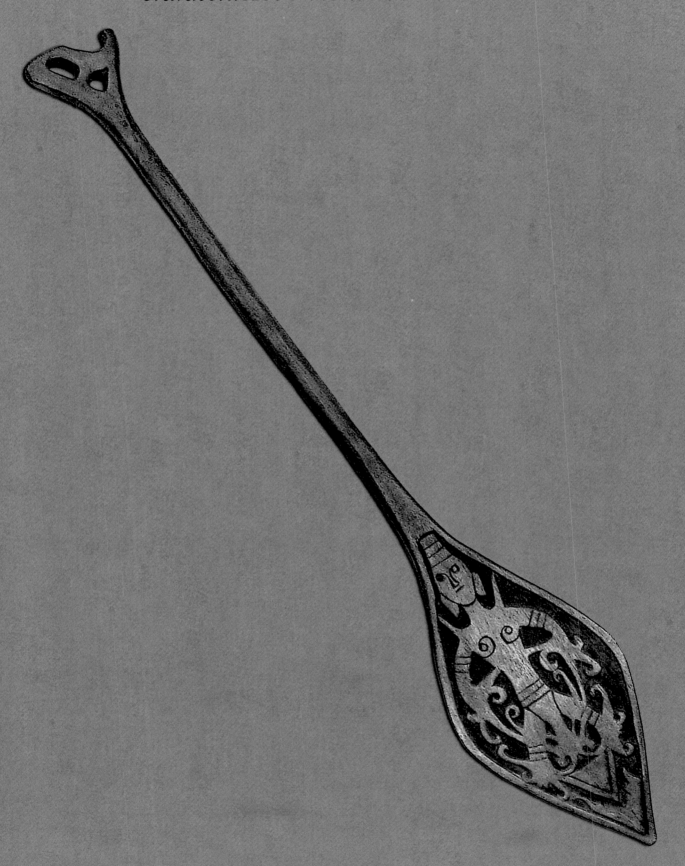

DaYak Extra #06 Headhunter Dugout Canoe Paddle

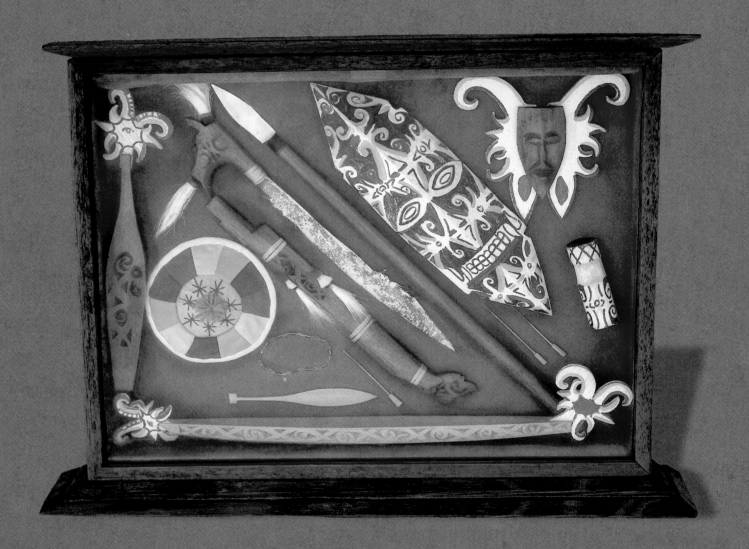

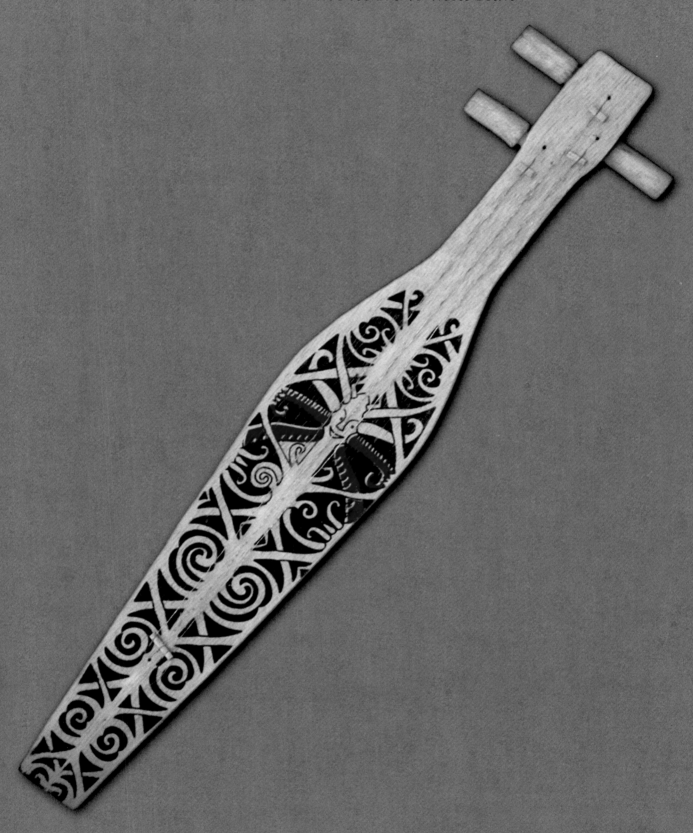

DaYak Extra #08 Hornbill Bird Guitar (Lute)

ROYAL COURT ARMOR

of

MOROLAND MUSEUM

field guide
Ninth edition Vol #1

Royal Court Armor of Moroland Musuem edition volume #01 has a variety of Armor sets to tempt your viewing pleasure.

This pictorial field guide will be a valuable asset to use when you are the hunt for an addition to your collection or if you are simply curious. It will have the same style of descriptions and lots of full color pages. It will also have those wonderful extras that you like so much. This edition will have a variety of Armor pieces from the Moro Tribe of the Phillipines. The style of these armor sets vary from tribe to tribe and from the material they are made from. This book is a pictorial book as it contains multiple pictures of each armor set and a brief description.

You will need to get the next issue to discover what other historical artifact delights await.

CONCLUSION

We hope this field guide of "DaYak Shields of Moroland Museum volume #2" is as much a helpful tool for you to use when you are hunting for your next big find or as an asset to your collection for visual reference purposes.

This guide is the second volume in a set of volumes that Moroland Historical Publications will publish on the Moroland Museum's DaYak warrior shields collection. The next volume will display more unique DaYak warrior shields not shown in the previous volumes.

These DaYak warrior shields are a unique part of the Malaysia/Borneo craftsmanship and cultural history. The Moroland Historical Publications team is dedicated to preserving this history by publishing guides which document these artifacts for all to see and learn from. This is one of the largest collections of this type of DaYak warrior shields (that we know of) and is most likely the very first time they have ever been displayed in this format to the public.

We hope you have enjoyed viewing this guide as much as our team has enjoyed creating it.

STATEMENTS

The writers of this book intentions were not to claim
to be or imply in any way that they are experts
or any kind of authority of Moroland
history, art, language, or weapons, or of
Philippine history, art, language, or weapons, or
of any other countries history, art, language, or
weapons. All of the weapons sizes and composition
were an estimated guess at the time of printing.

All items are shown "as is". MOROLAND MUSEUM will
not make any representation of warranty,
expressed or implied, as to the marketability,
fitness or condition of the items shown or
described or as to the correctness of
description, genuineness, attribution,
size, provenance, location of origination,
or period of the shown items.

The writers would like to say

THANK YOU

to those whose support and input
made this book possible.

Our Spouses, Our Children, Our Friends
We would also like to thank those curious
collectors who before us have preserved
this part of our past and those whose
skills, patience, and imagination made these
items to begin with.

Moroland Museum Historical Publications Book Series:

Kerises of Moroland Museum........................**Book #1** on the unique Kerises (wavy blade swords) from the Moroland Museum Historical Archives, Volume #1.

Weapons of Moroland Museum.....................**Book #2** on the unique Weapons from the Moroland Museum Historical Archives, Volume #1.

Artifacts of Moroland Museum.....................**Book #3** on the unique Artifacts from the Moroland Museum Historical Archives, Volume #1.

**Souvenir Weapons Plaques
of Moroland Museum**....................................**Book #4** on the unique Plaques from the Moroland Museum Historical Archives, Volume #1.

Igorot Shields of Moroland Museum............**Book #5** on the unique shields from the Moroland Museum Historical Archives, Volume #1.

DaYak Shields of Moroland Museum...........**Book #6** on the unique shields from the Moroland Museum Historical Archives, Volume #1.

**Souvenir Weapons Plaques
of Moroland Museum**....................................**Book #7** on the unique Plaques from the Moroland Museum Historical Archives, Volume #2

All Moroland Museum books are available for purchase on the Amazon website and can be purchased with discount when buying in bulk.

Made in the USA
Lexington, KY
11 March 2018